HOLLYWOOD CATS

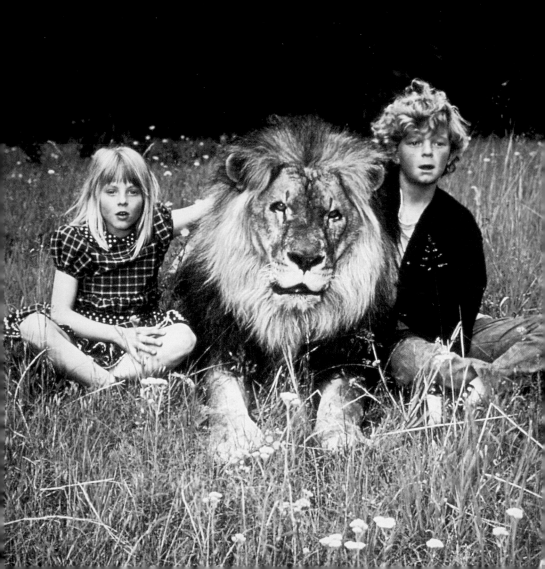

HOLLYWOOD CATS

Ann Lloyd

BARRON'S

INTRODUCTION

Food, glorious food…

Cats are some of the most independent, reserved, and bewitching creatures around. They are warm and affectionate when they wish to be stroked, pampered, or fed, but as every cat-lover and owner will admit, cats don't take kindly to orders. So, you can imagine the challenges a filmmaker experiences when trying to direct a feline actor. Cats usually participate on the understanding that they will be rewarded, primarily with food. Frank Inn, one of Hollywood's top-ranking animal trainers, observed that the best cat actors have no interest in delighting their owner, their trainer, or the public—they just want their next titbit. Unfortunately, cats have very small stomachs, and as their hunger fades, so does their interest in acting. A successful movie performance, therefore, involves a great deal of cajoling, patience, and food!

Life on set

Cat trainers will tell you that the easiest cat actors to work with are also the greediest. On the set of *Rhubarb*, Orangey, the winner of several PATSY (Picture Animal Top Star of the Year) Awards, had an ornery attitude toward filming which was compounded by his dislike of Ray Milland, the movie's human star. Frank Inn, who had the dubious honor of being Orangey's owner and trainer, solved this problem by smearing Ray Milland with liver paste. Unfortunately, such solutions are short-lived. Trainers know that cats tend to become lazy when they are served only one kind of food, and can't always be bothered to earn the same food again and again. Solutions to the problem constantly have to be reinvented to capture the puss's waning interest. In Orangey's case, Inn cleverly replaced the liver paste with catnip to ensure Orangey kept up his charade of liking Milland.

Star quality

The "star quality" of a movie cat is very specific. It is highly unlikely that one cat actor will be able to portray all manner of moods, so cat trainers often have to find several "matching" cats, one that spits, one that purrs, one that sleeps elegantly, one that hunches its back and looks sinister, one that does "alert and intelligent", one that walks in a

straight line, one that yawns, one that looks as if it's just seen a ghost (or a dog), one that washes its whiskers, and one that can sit neatly on people's shoulders. A very lucky trainer *may* have a puss that looks intelligent *and* walks in a straight line, but it's pretty rare.

"Niche" roles

Ginger or tabby cats are usually the moggies of choice for filmmakers. Directors prefer them because they are relatively easy to work with and cameramen find their coloring easier to film. White cats are usually amiable and co-operative, but are difficult to photograph due to a lack of contrast. Black cats are dreaded—not only are they scornful of the whole filmmaking business, but they're extremely difficult to light.

Each type, however, has its essential place in Hollywood movies. White cats are a symbol of elegance, sensuality, and luxury. Ginger toms and tabbies are the alley cats, the brawlers, and the tough survivors, and black cats, of course, are the cats of mystery and superstition. They occasionally signal good luck, but far more often they are symbolic of murder, horror, evil, and witchcraft! *The Black Cat, The Cat Creeps, The Shadow of the Cat*, and *The Curse of the Cat* are

all well-known creepy cat films that still have the ability to raise the hairs on the back of your neck.

Apart from animated movies and cartoons, there have not been many movies specifically about cats. There are, though, many, many movies in which cats play a pivotal role in defining the film's plot, its ambiance, or the nature of its characters. When a cat walks into a shot—watch out! Nothing is going to be quite the same again.

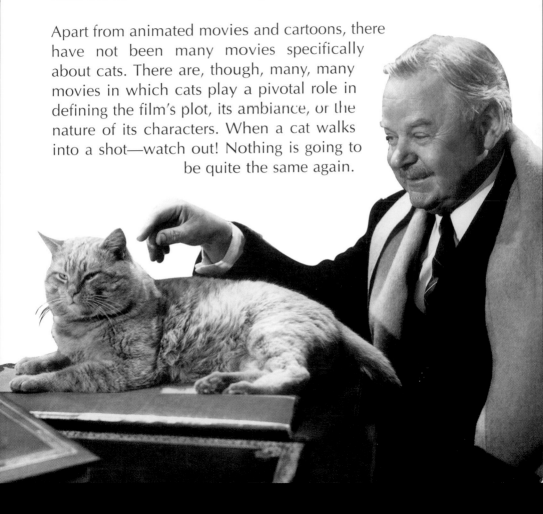

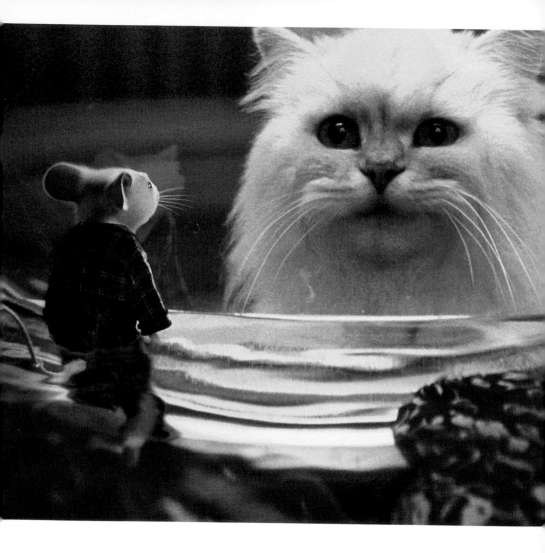

STUART LITTLE: Snow, where are you going?
SNOWBELL: Oh, I gotta yawn, stare at traffic, lick myself. And believe me, that could take hours if you do it right.

 ### STUART LITTLE
Dir. Rob Minkoff (1999)

When the Little family adopts orphaned mouse Stuart, their affronted cat Snowbell is determined to get rid of him. Boone Narr, the movie's head animal co-ordinator, had to scour the animal shelters around Hollywood until he found five identical white Chinchilla Persians with loads of purrsonality—but different talents and abilities— to tackle the complexities of the Snowbell role.

Those who play with cats must expect to be scratched.

Cervantes

 EYE OF THE CAT
Dir. David Lowell Rich (1969)

In this horror movie, a scheming woman named Kassia convinces her boyfriend, Wylie, that they should murder his wealthy aunt—but they fail to consider the old woman's beloved pet cats. When cat-phobic Wylie accidentally electrocutes one of the cats, the rest swarm on Kassia and tear her to pieces. Cats in groups can look rather tame, but Ray Berwick, who trained the birds for Hitchcock's classic thriller, *The Birds*, used his skills to create a superb cast of crazed and sinister felines.

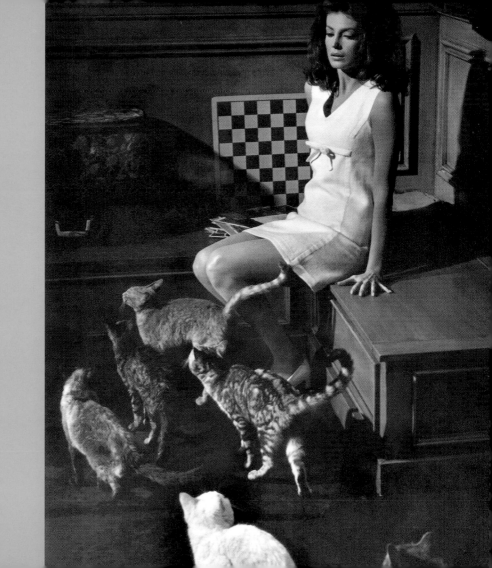

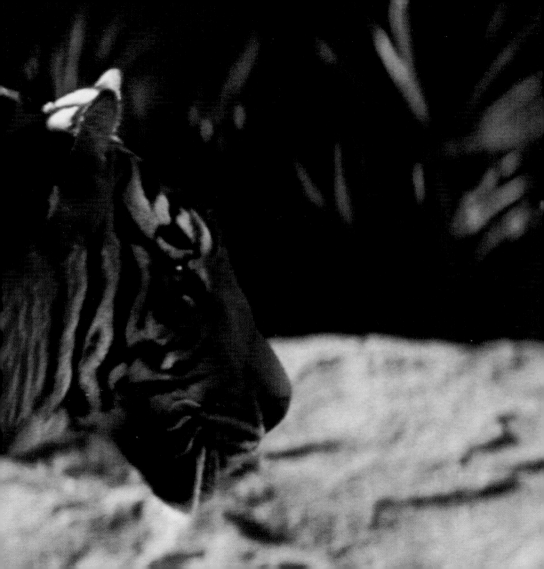

MOWGLI: The more I learn what is a man, the more I want to be an animal.

 ## RUDYARD KIPLING'S THE JUNGLE BOOK

Dir. Stephen Sommers (1994)

In Disney's live-action version of *The Jungle Book*, the villain Shere Khan is in control until Mowgli (played by Jason Scott Lee) confronts him and, after out-staring and out-roaring the mighty tiger, becomes King of the Jungle. Shere Khan was played by a tiger called Bombay who, when not roaring in the jungle, was well known to viewers for his starring role in the Esso commercials.

> **If animals could speak, the dog would be a blundering, outspoken, honest fellow—but the cat would have the rare grace of never saying a word too much.**
>
> Philip Gilbert Hamerton

 ## THE INCREDIBLE JOURNEY
Dir. Fletcher Markle (1963)

To make a successful movie of Sheila Burnford's classic tale of a Siamese cat named Tao and two dogs, Bodger and Luath, finding their way home across the wilds of Canada, the filmmakers knew that they needed three animal actors who felt genuine warmth for one another. The dogs posed little problem, but it took two months of rehearsals before Syn—the main cat actor, who played Tao—ceased his furious, ear-splitting yowls and finally rubbed himself affectionately against a surprised Bodger's legs.

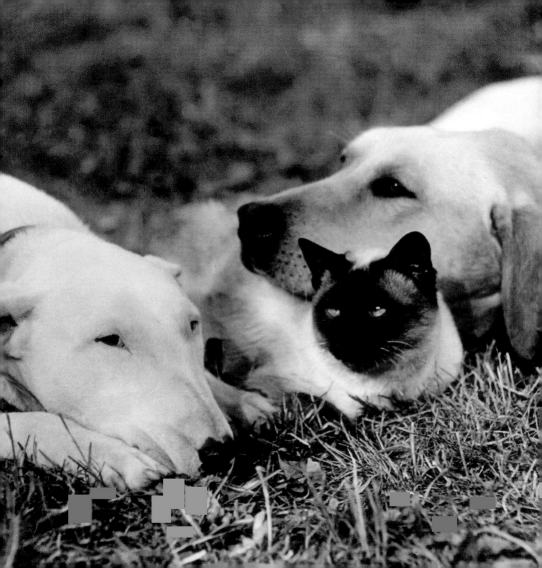

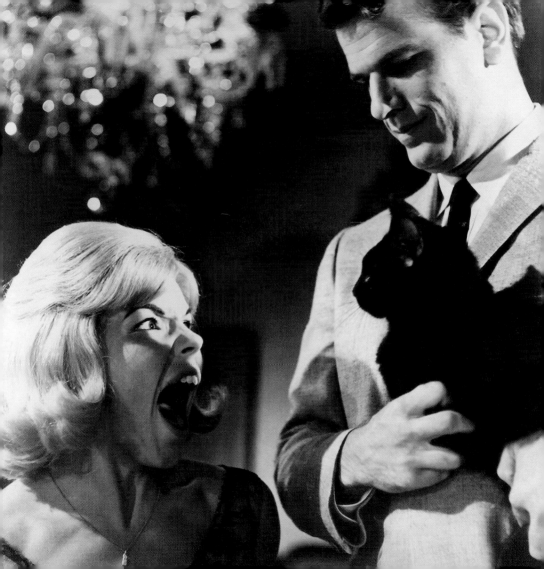

Beware in the presence of cats…

Friedrich Nietzsche

 THE BLACK CAT
Dir. Harold Hoffman (1966)

Edgar Allen Poe's short story, *The Black Cat*, is the original source of this and many other horror movies, and it tells the tale of a man's descent into madness. The man murders his wife and then bricks her dead body into the cellar wall. However, the ghost of her black cat, which he had already viciously killed, returns and gives him away. Poe took his own cat, Catarina, with him everywhere he went and, although she was a tortoise-shell and not a black cat, he credits her with being his inspiration for this story.

DAVE BUZNUK: His name's not Fat Shit Cat, it's Meatball!

 ANGER MANAGEMENT
Dir. Peter Segal (2003)

Reviewers universally praised the performance of Meatball, the portly tabby cat who models the clothes that Dave Buznuk (played by Adam Sandler) designs for overweight cats. The real Meatball wasn't at all fat, so he had to wear a specially designed fiber-filled fat-cat suit under his various designer outfits. Electric fans were kept running on set at all times to make sure that Meatball didn't overcook.

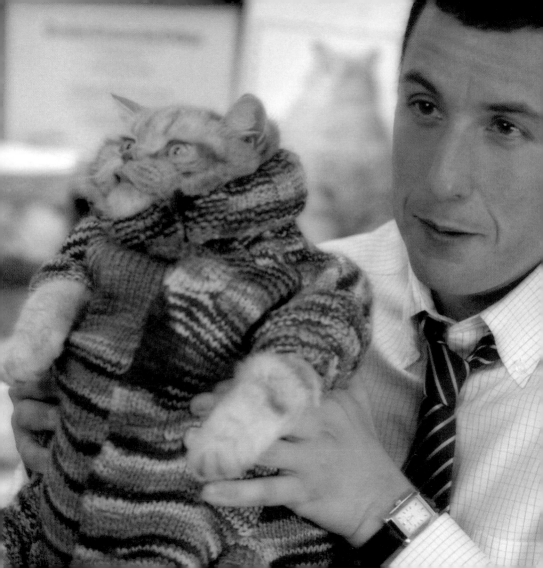

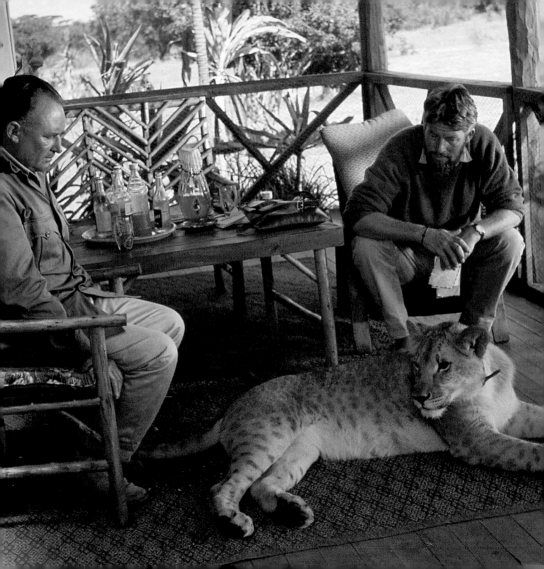

> A cat pours his body on the floor like water. It is restful just to see him.

William Lyon Phelps

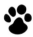 **BORN FREE**
Dir. James Hill (1966)

Born Free was the first movie based on Joy Adamson's best-selling books, and it tells the true story of how she and her game-warden husband George successfully returned a lion called Elsa to the wild. George Adamson (played by Bill Travers in the movie) was very involved in the making of *Born Free*—he served as a technical advisor and animal trainer, and his experience with lions was invaluable. He didn't forget his devotion to conservation, however. When filming finished, he took three of the lion actors—Boy, Girl, and Ugas—home with him to try to rehabilitate them back into the wild.

This FBI agent is putting his life on the line. Fortunately, he's got nine.

Tagline from the movie

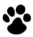 ## THAT DARN CAT
Dir. Bob Spiers (1997)

In this Disney remake, a cat called D.C. (short for Darn Cat!) and his teenage owner help the FBI find a pair of kidnappers. It was the first starring role for cat actor Elvis, who was originally brought in just as a stand-in for the three experienced cats already chosen to play D.C. However, such was Elvis's versatility and intelligence—as well as his onscreen magnetism and around-the-set "attitude"—that he quickly became the movie's star.

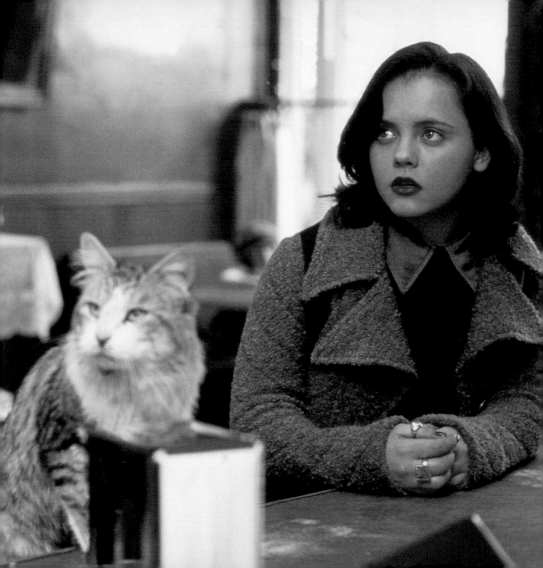

Even a cat is a lion in her own lair.

Indian proverb

 SLEEPWALKERS
Dir. Mick Garris (1992)

Horrormeister Stephen King's *Sleepwalkers* are bloodsucking shape-shifters whose only mortal enemy is the domestic cat. Clovis, police cat extraordinaire, marshals an army of local moggies to vanquish the sleepwalking monsters. Sadly, for audiences expecting to be scared witless, the movie's team of cat trainers had great difficulty in persuading the cats to pay any attention to the Sleepwalkers—even when the monsters were liberally smeared with cat food. Instead of an army of ferocious felines, the screen shows a bunch of rather bored felines.

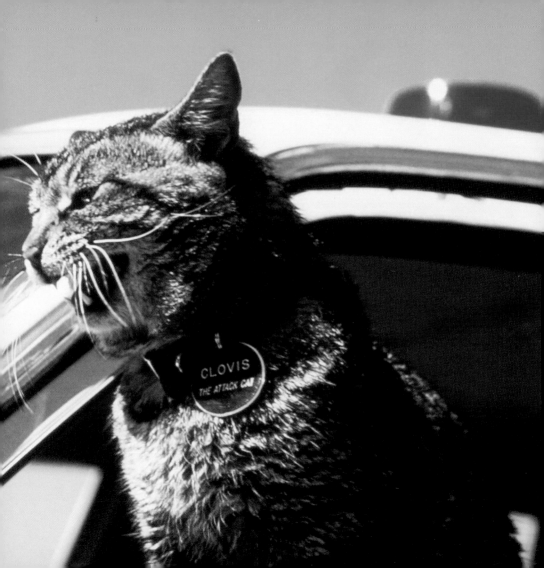

He's the King of Beasts... who just couldn't quite be Beastly!

Tagline from the movie

 CLARENCE THE CROSS-EYED LION
Dir. Andrew Marton (1965)

When reports of a lion terrorizing an African village are investigated, it transpires that he is, in fact, a pussycat of a beast who is so visually challenged that he is unable to hunt—he has merely been foraging for food. The lovable lion actor Clarence had a stand-in called Leo, who had been badly treated by his previous owners and was not so friendly. Leo's acting skills, therefore, were saved for the snarling shots and for scenes that didn't require a close proximity to people.

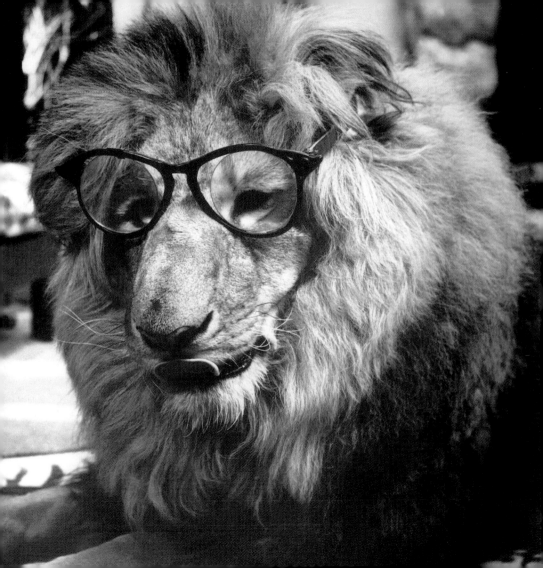

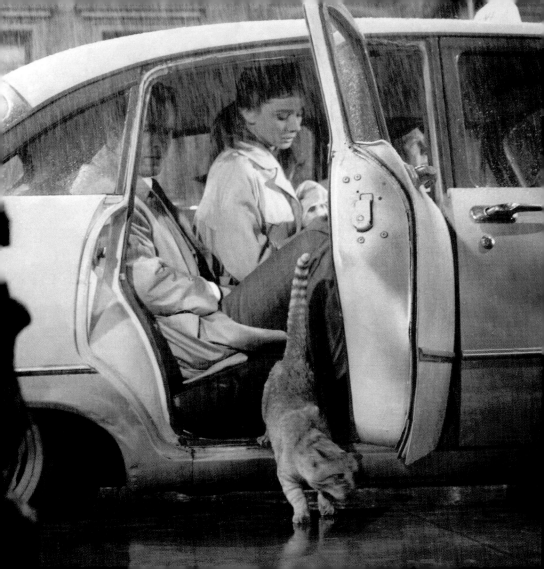

HOLLY GOLIGHTLY: We're alike, me and Cat. A couple of poor nameless slobs.

 BREAKFAST AT TIFFANY'S
Dir. Blake Edwards (1961)

The most important relationship for the chic, kooky Manhattan playgirl Holly Golightly (played by Audrey Hepburn), is with her cat, who is simply called "Cat" and was played by cat star Orangey. Cats were also special to Audrey Hepburn herself, who said in later interviews that the scene where she, as Holly, has to throw Cat out of a car into the rainy street was the most distasteful thing she ever had to do on film.

MR. TINKLES: Like a powerful, dark storm, I will make my presence known to the world. Like a seeping mist, I will creep into the dogs' center of power, and make them quake in fear at the very mention of my name!

 ## CATS & DOGS
Dir. Lawrence Guterman (2001)

In the opening rounds of the Great War between Cats & Dogs, the cats are under the command of power-hungry Persian, Mr. Tinkles, who has his mind set on nothing less than total world domination! The filmmakers also found Mr. Tinkles a bit of a handful—he was the most difficult character to portray and they had to build a highly sophisticated life-sized puppet to act as a "stunt double" for the real cat actors, Foster and Fritz. It took months of meticulous work to create a realistic-looking puppet version of Mr. Tinkles, and six puppeteers were needed to control him.

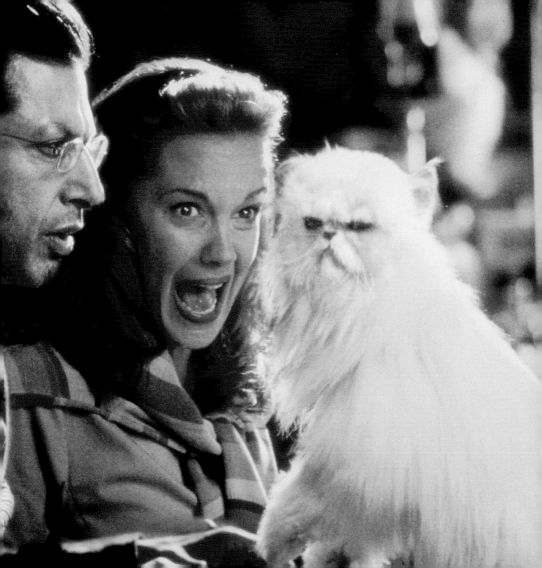

I should say that his judgment respecting the warmest place and the softest cushion in a room is infallible, his punctuality at meal times is admirable, and his pertinacity in jumping on people's shoulders till they give him some of the best of what is going, indicates great firmness.

Thomas Henry Huxley

 ## THE LONG GOODBYE
Dir. Robert Altman (1973)

In Robert Altman's reworking of *The Big Sleep*, his shambling, laid-back, wisecracking Philip Marlowe is a much cooler customer than he appears. However, when it comes to his orange tabby cat, he is putty in its paws. The film opens with Marlowe bringing home the wrong type of cat food, whereupon the cat scratches him and walks out! Six matching orange tabbies, each with its own unique talents and special skills, were hired to play the cat that Marlowe remains obsessed with for the rest of the movie.

> A Cat, with its phosphorescent eyes that shine like lanterns and sparks flashing from its back, moves fearlessly through the darkness, where it meets wandering ghosts, witches, alchemists, necromancers, grave-robbers, lovers, thieves, murderers, grey-cloaked patrols, and all the obscene larvae that only emerge at night.
>
> Théophile Gautier

 PET SEMATARY
Dir. Mary Lambert (1989)

Stephen King got the idea for his book on which this movie is based while his family was burying his daughter's dead cat. The dark tale begins when Church, a beloved family cat, is killed and buried in a sacred burial ground that returns the dead to life—but with murderous souls. The story frightened King so much while he was writing it that three years passed before he could bring himself to publish it!

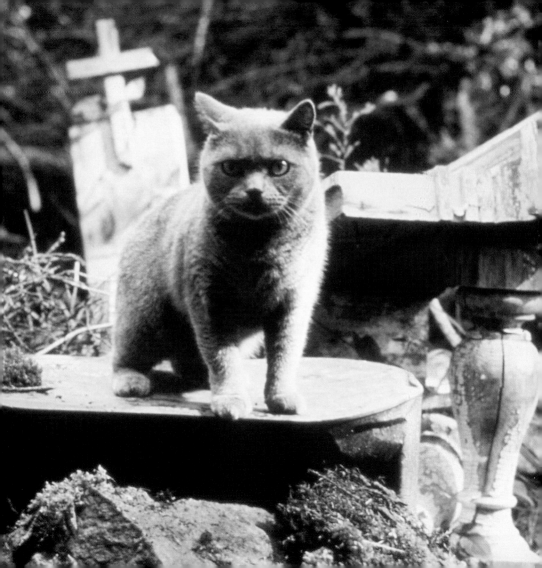

Animals are such agreeable friends— they ask no questions, they pass no criticisms.

George Eliot

 ## NAPOLEON AND SAMANTHA
Dir. Bernard McEveety (1972)

In this very thoughtful Disney movie, 11-year-old Napoleon and his grandfather adopt Major, a circus lion in need of a retirement home. When his grandfather dies, to avoid being put into foster care, Napoleon heads for the hills with Major and his school friend Samantha. The role of Samantha was Jodie Foster's feature-film debut and she got off to a very rough start. One of the lions playing Major mauled her, and she bears traces of the scars to this day.

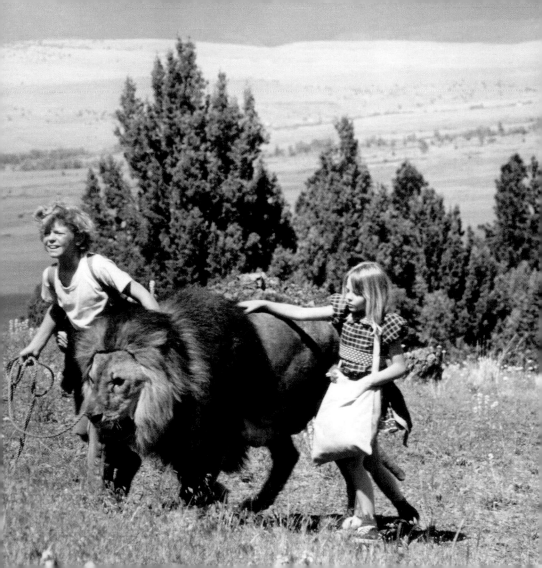

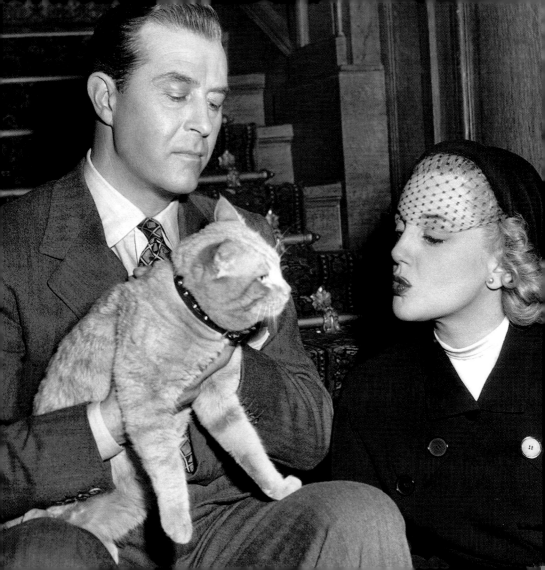

ERIC YEAGER: Stroke him very gently on his head.

POLLY SICKLES: Why, he doesn't even hiss!

ERIC YEAGER: You're now a member of the club.

 ### RHUBARB
Dir. Arthur Lubin (1951)

Rhubarb, the story of a cat who inherits a fortune—and a baseball team—was cat actor Orangey's first movie role. Orangey was a troublesome star from the start, but his trainer Frank Inn quickly realized that his protégé was over-stretched and told the movie's producers: "You can't ask him to be twenty-two cats!" The answer? The company immediately hired 22 cat extras to act as doubles and stand-ins whenever Orangey needed a break.

Dogs have owners,
cats have staff.

Anonymous

 THE STARS FELL ON HENRIETTA
Dir. James Keach (1995)

Mr. Cox—played by Robert Duvall—is an elderly "hunchmeister" who drifts into the small town of Henrietta because he believes there is oil lying under most of the farmland in Texas. He is accompanied throughout his travels by his tabby cat Mathilda. She is his inseparable friend and she spends most of the movie either at his heels or on his shoulder. It was essential that Robert Duvall and his feline co-star got along well during filming and, thankfully, they did. Mathilda's trainers were delighted by Duvall's "cat-dexterity" and the ease with which he conveyed the pivotal relationship between man and cat.

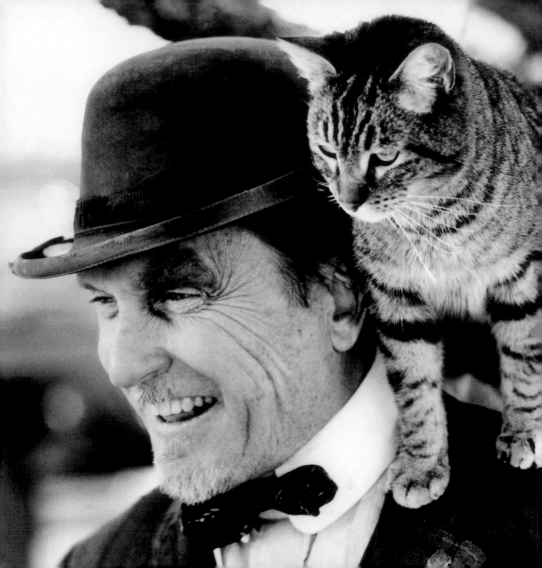

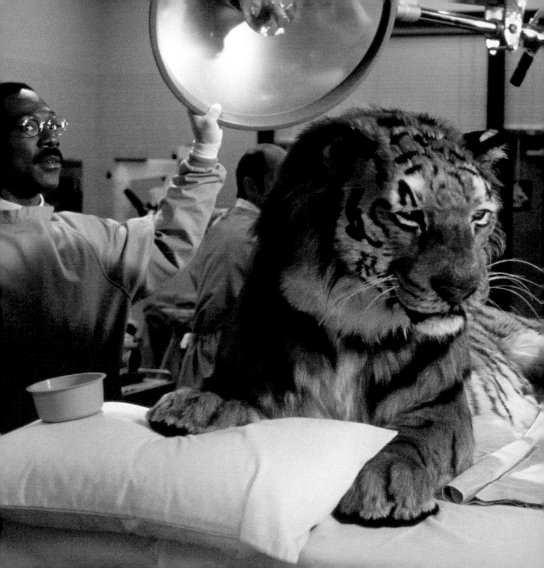

DOCTOR DOLITTLE: Maybe it's your destiny to be the only tiger that everybody remembers.

 DOCTOR DOLITTLE
Dir. Betty Thomas (1998)

In many of the shots involving Doctor Dolittle and a depressed circus tiger in this movie, Eddie Murphy, who played Dolittle, worked with the animal's animatronic double. On the days when the real tiger was needed, the tiger's scenes were filmed first, because he was less controllable and predictable than the other animals were. His trainers never knew exactly what he was going to do next—which wasn't much of a comfort to a very nervous Eddie Murphy!

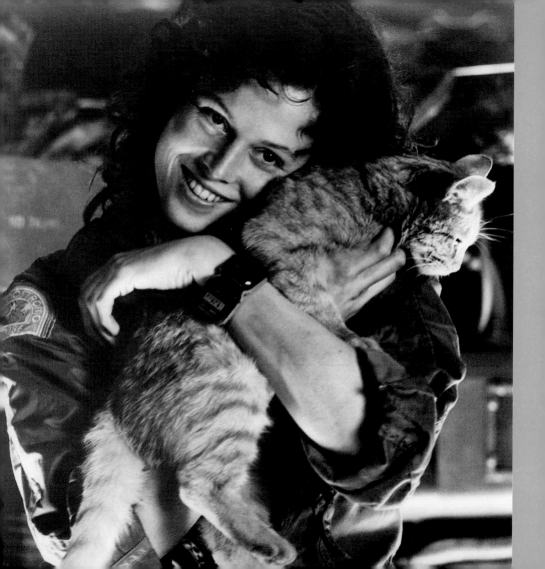

There are many intelligent species in the universe. They are all owned by cats.

Anonymous

 ALIEN
Dir. Ridley Scott (1979)

The creators of this science fiction classic have been accused of putting the ginger, purring Mr. Jones aboard the Nostromo space-tug as the ultimate "Spring-Loaded Cat." This phrase is attributed to journalist Joe Kane and it refers to that typical scary movie technique of using a fake scare to make the audience jump just before the real scary moment happens. Mr. Jones jumps out and frightens the space ship's crew three times in the movie. They all relax when they realize that it is just the cat and not the alien they feared, but then suddenly the *real* monster appears.

We're all born bald, baby!

Telly Savalas

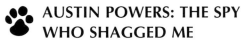

🐾 AUSTIN POWERS: THE SPY WHO SHAGGED ME

Dir. Jay Roach (1999)

In this Bond-movie spoof, arch-villain Blofeld and his fluffy white Persian cat become Dr. Evil and the hairless cat, Mr. Bigglesworth. The cat that plays Mr. Bigglesworth is not, in fact, a Persian that has gone bald, but a pedigree Sphynx by the name of Ted Nude-gent. Dr. Evil's pint-sized clone, Mini-Me, has his own pint-sized cat, called Baby Bigglesworth, who was played by three aptly-named Sphynx kittens—Mel Gibskin, Paul Nudeman, and Skindiana Jones.

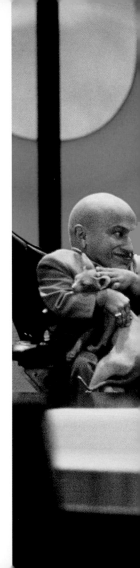

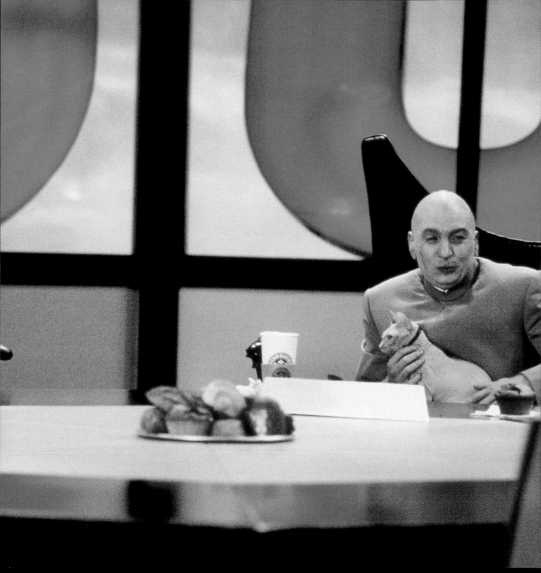

It is a difficult matter to gain the affection of a cat. It is a philosophical animal, tenacious of his own habits, fond of order and neatness, and disinclined to extravagant sentiment. If you are worthy of its affection a cat will be your friend, but never your slave.

Théophile Gautier

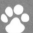 **CAT'S EYE**
Dir. Lewis Teague (1985)

A mysterious stray cat known as "The General" roams through all three of the Stephen King tales that make up this movie, and determines the outcome of each of the mysteries. The General originally had a much bigger role. However, because a little girl played by Drew Barrymore died in the first version, the movie's anxious backers immediately demanded cuts and many of the cat's finest scenes were left on the cutting-room floor.

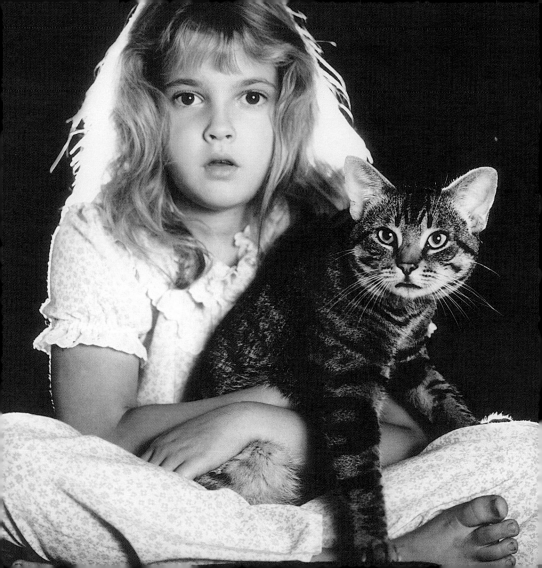

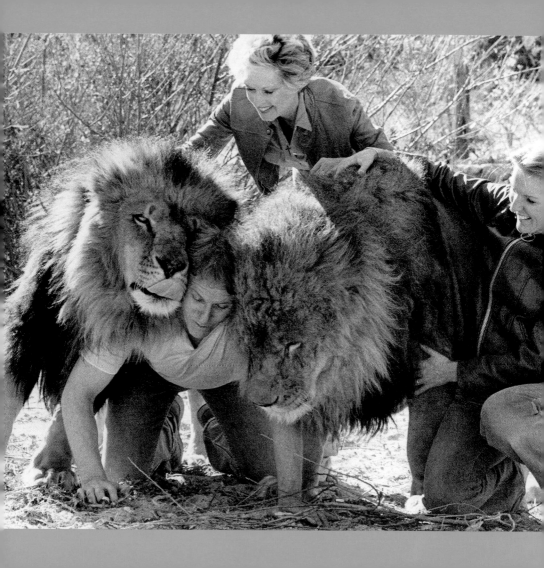

If God created man in his own image, you've got to wonder; in whose image did he create the nobler cat?

Anonymous

 ROAR
Dir. Noel Marshall (1981)

This movie about a family dedicated to preserving big cats in Africa was actually made by a family—director and star Noel Marshall, his wife Tippi Hedren, his three sons, and her daughter, Melanie Griffith. The movie took 11 years to make because of a series of disasters that occurred during filming. Marshall was severely mauled by one of the lions and hospitalized, and then Melanie Griffith was so badly clawed that she needed plastic surgery. Finally, a dam break in 1978 wreaked havoc—the set was destroyed and several of the lions, including Robbie the star, were killed.

After dark all cats are leopards.

Native American proverb

 THE INCREDIBLE SHRINKING MAN
Dir. Jack Arnold (1957)

In between helping cat actor Orangey to win animal "Oscars" (called PATSY Awards) for his roles in *Rhubarb* and *Breakfast at Tiffany's*, trainer Frank Inn coached him for this small but very significant role as Scott Carey's angry cat in *The Incredible Shrinking Man*. Despite his huge onscreen fame, Orangey was notoriously bad-tempered, and he was so difficult to work with that even his own trainer admitted to disliking him.

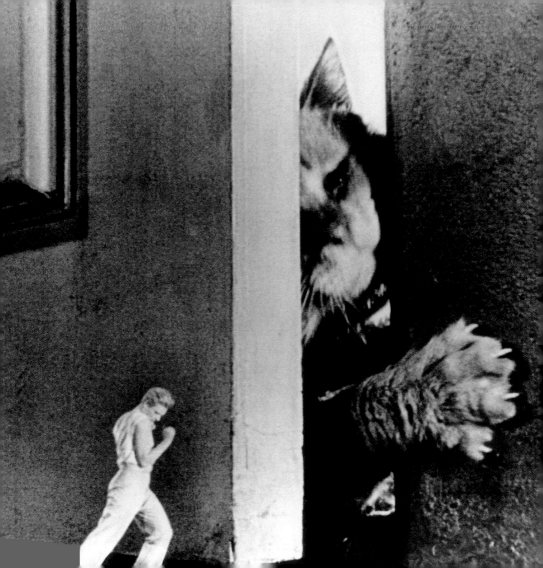

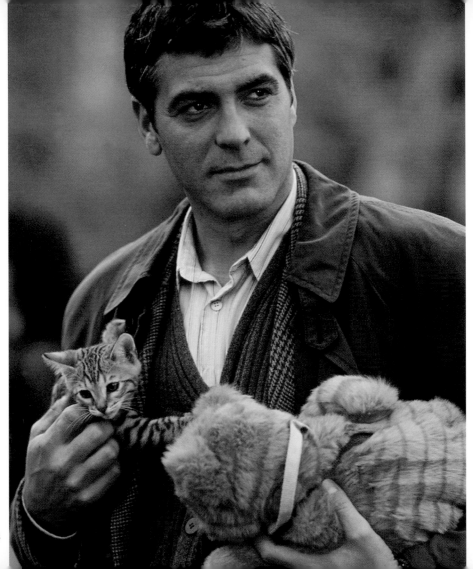

The smallest feline is a masterpiece.

Leonardo da Vinci

 ONE FINE DAY
Dir. Michael Hoffman (1996)

In this romantic comedy, Jack, played by George Clooney, is a career-oriented single parent struggling with a childminding crisis. He has to buy off his cat-crazy daughter Maggie with a kitten after her tearfully determined declaration "I won't leave the shop without one!", thereby adding another crisis to his life. They take home a beautiful Bengal "cub." A descendent of the Asian Leopard Cat, which is now an endangered species, the Bengal siblings that play Maggie's new pet look exactly like tiny leopards.

A Close Encounter
of the "Furred" Kind!

Tagline from the movie

 THE CAT FROM OUTER SPACE
Dir. Norman Tokar (1978)

When a spacecraft crash-lands on Earth, its sole occupant is a telepathic, wisecracking space-cat, bizarrely named Zunar J5/90 Doric 4-7, but rapidly renamed "Jake." From the outset, the crew working on the movie noticed an apparent personality clash between the cat actors that played Jake— Abyssinian cat Rumpler and his sister Amber—and the movie's human star, Ken Berry. The cats' tails would whip angrily whenever Berry touched either of them. Wherever the fault lay, this was the only role in Rumpler and Amber's short movie careers.

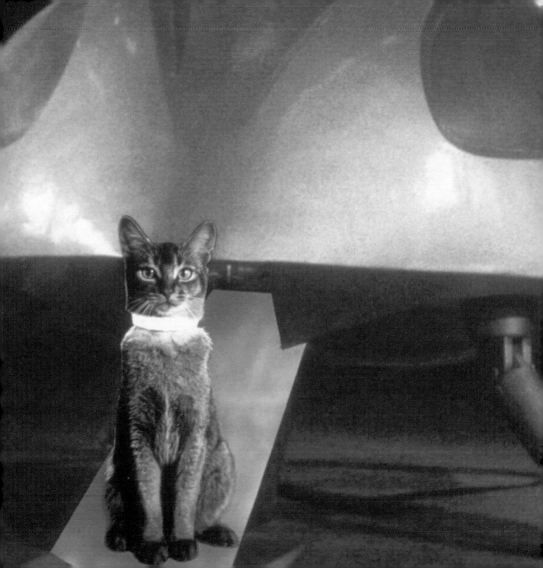

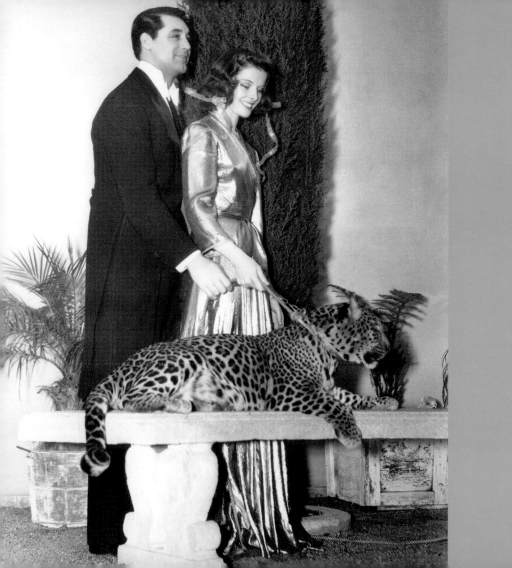

Of all God's creatures, there is only one that cannot be made slave of the leash. That one is the cat.

Mark Twain

 BRINGING UP BABY
Dir. Howard Hawks (1938)

When a madcap heiress decides to rescue an absent-minded palaeontologist from his impending marriage, she chooses as her accomplice her pet tiger, Baby (played by Nissa). Blending shots of Nissa with those of the other cast members, who were filmed separately, called for trick photography that was groundbreaking in the 1930s. The sound engineers also had their work cut out for them because Nissa's purr was far too loud for the microphones. They amplified the voice of the studio cat fourteen times, and used that as the tiger's purr instead.

> **If you want to know the character of a man, find out what his cat thinks of him.**
>
> Anonymous

 YOU ONLY LIVE TWICE
Dir. Lewis Gilbert (1967)

A beautiful white fluffy cat becomes the trademark of Blofeld—head of the super-secret organization SPECTRE and archenemy of secret agent James Bond—well before we ever see Blofeld's face. In this movie, Blofeld (played by Donald Pleasance) appears, bald, scarred, and sinister. The cat actor is Persian cat Salomon, who also appeared in *A Clockwork Orange* and a famous series of Kosset Carpet commercials.

Cats are a mysterious kind of folk.
There is more passing in their minds
than we are aware of. It comes
no doubt from their being too familiar
with warlocks and witches.

Sir Walter Scott

 BELL, BOOK AND CANDLE
Dir. Richard Quine (1958)

This movie is the story of a beautiful modern-day witch who becomes entangled in her own magic. Her familiar spirit is Pyewacket, a Siamese cat played by cat actor Cleo, who won a PATSY Award (animal Oscar) for her role in the movie. The cat Pyewacket got its name from another witch's familiar, which was found in the historical records of Witch Finder General Matthew Hopkins. His papers mention a woman accused of witchcraft in 1644, who confessed to having ten animal familiars, called Pyewacket, Holt, Jarmara, Vinegar Tom, Sacke, Sugar, Newes, Ilemauzer, Pecek in the Crowne, and Greizzel Greedigutt.

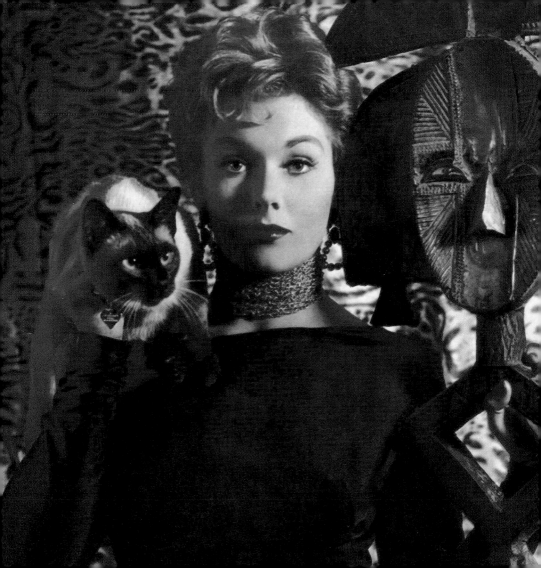

> I've survived many mishaps in my life and I didn't necessarily want to end up in the belly of a lion as some big cat's breakfast.

Richard Harris

TO WALK WITH LIONS
Dir. Carl Schulz (1999)

Richard Harris portrays George Adamson in this account of Adamson's mission to run a wildlife sanctuary in Kenya. At first, Harris requested a stunt double because he didn't wish to be near the lions, even though they weren't wild animals, but highly trained lions. However, upon meeting them, Harris decided he should do his own lion scenes and set about getting to know them. "I went down every morning. I would lean in front of their cages and talk—just for two or three minutes so I didn't bore them. Then I went down again every day and spoke to them again." Harris bonded so well with the lions that he missed them terribly when they flew back home.

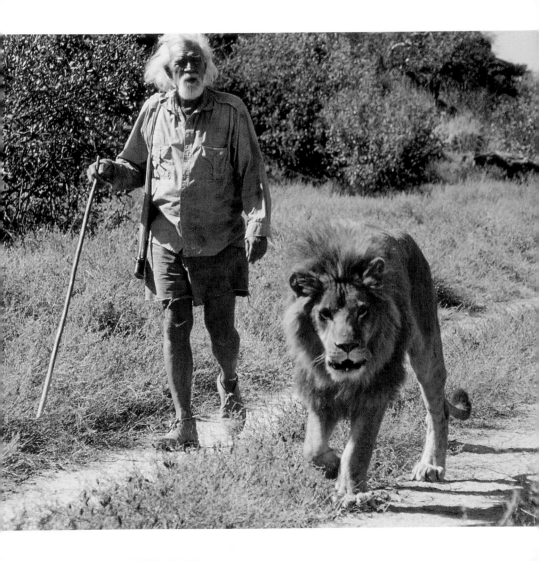

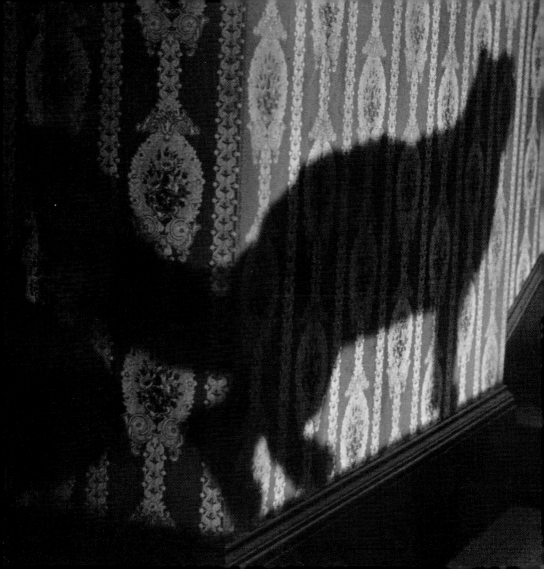

A cat is more intelligent than people believe, and can be taught any crime.

Mark Twain

SHADOW OF THE CAT
Dir. John Gilling (1961)

Tabitha, the placid kitty who becomes a ferocious and vengeful feline, is the central character in this tale of multiple murders. Much of the fear factor was provided by glimpses of her sinister shadow slinking up stairs and around corners. The movie asked a lot of both cat and trainer because the process of effectively lighting and shooting her shadow was far more exacting and time-consuming than straightforward cat action shots. Fortunately, Tabitha proved to be not only versatile, but also exceptionally patient, resulting in a classic Hammer Horror flick.

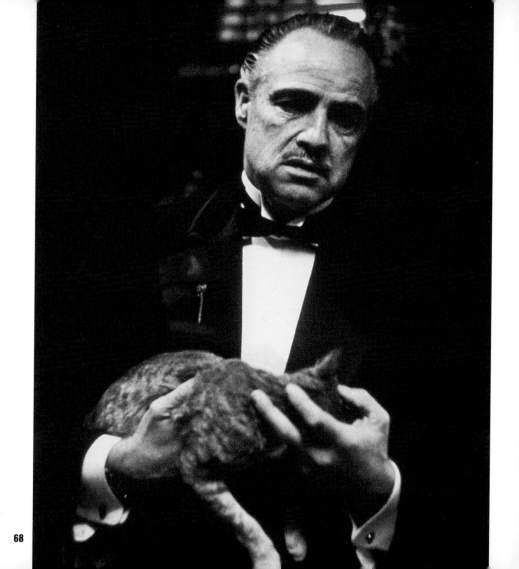

I purr, therefore I am.

Anonymous

 THE GODFATHER
Dir. Francis Ford Coppola (1972)

The cat that is held and stroked by Don Vito Corleone (played by Marlon Brando) in the opening sequences of *The Godfather* has been immortalized as part of *the* image of the infamous Mafia boss. The cat was, in fact, a stray that Marlon Brando found on the Paramount lot, and it was he who added the cat to the script. The cat seemed very happy with this arrangement, and it purred so loudly that patches of the dialogue were drowned out and had to be re-recorded.

THOMASINA: They started out by calling me Thomas, but when they, um, got to know me better, they changed it to Thomasina.

 ## THREE LIVES OF THOMASINA
Dir. Don Chaffey (1963)

This heartwarming movie about a young Scottish girl and her cat, Thomasina, is a classic tale of a cat reuniting her human family and bringing out the best in each of them. It is based on a novel called *Thomasina, The Cat Who Thought She Was God* by Paul Gallico, who was devoted to and delighted by cats, and probably based the character of Thomasina on his own two Ukranian Grays, Chin and Chilla. Gallico frequently wrote from their viewpoint, claming that he translated their words from "the Feline," and the filmmakers continued this tradition by having the cat, voiced by Elspeth March, narrate the movie.

> With Nature's pride, and richest
> furniture,
> His looks do menace heaven and
> dare the Gods.

Christopher Marlowe

PASSION IN THE DESERT
Dir. Lavinia Currier (1997)

A young soldier (played by Ben Daniels) who becomes lost in the Egyptian desert falls in love with a leopard in this adaptation of Honoré de Balzac's short story. The movie was nine years in the making because, for leopards to be safe to work with, they have to be bred and trained especially for the job. Big cat specialist Rick Glassey had to raise twin leopard cubs Mowgli and Bagheera, plus their younger sister Akela, and thoroughly accustom them to human companionship before filming could begin. Even with all this planning, Ben Daniels had quite a few close shaves on set.

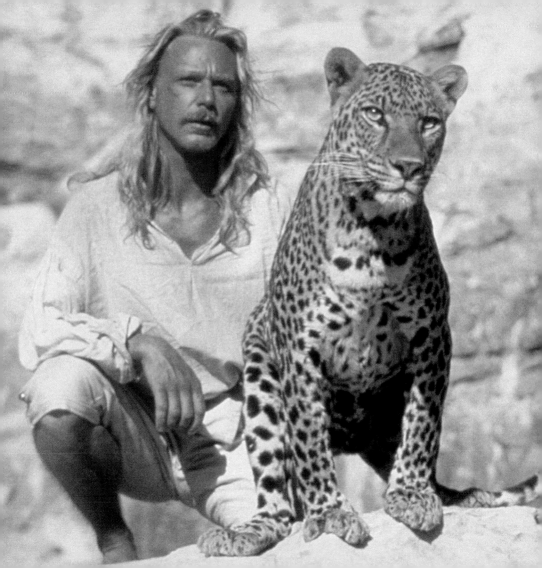

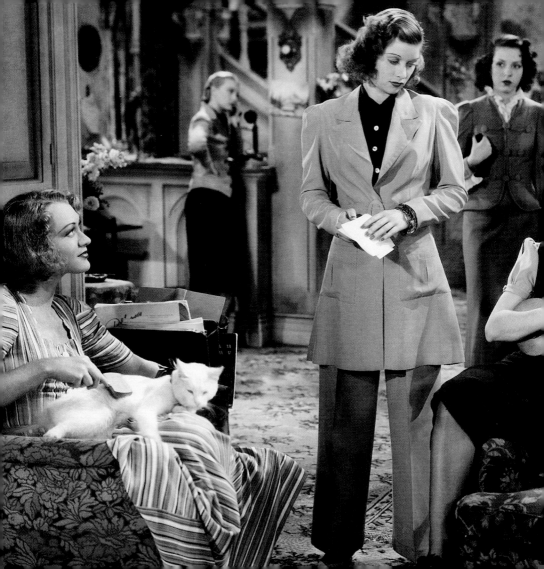

He lies there, purring and dreaming, shifting his limbs now and then in an ecstasy of cushioned comfort. He seems the incarnation of everything soft, and silky, and velvety, without a sharp edge in his composition, a dreamer whose philosophy is sleep and let sleep...

Saki

 ## STAGE DOOR
Dir. Gregory La Cava (1937)

Frank Weatherwax, who is best known as a trainer of famous movie dogs, had a cat actor called Whitey to handle in this tale of a group of stage-struck young ladies living out their dreams in a New York boarding house. However, it was actress Eve Arden who was largely responsible for Whitey's presence in the movie. The feisty actress had no fear of being upstaged by an animal, and Whitey (who played her pet Henrietta) spent most of the movie draped over her arms or shoulders, enjoying all the pampering he could get.

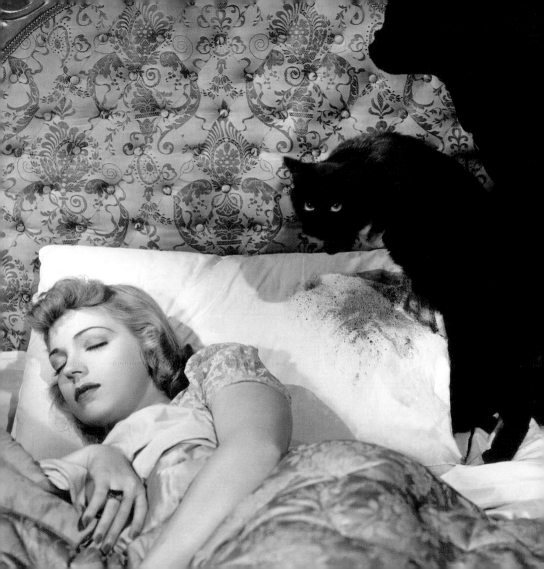

Black cats carry the souls of the dead to the other world.

Finnish saying

 THE BLACK CAT
Dir. Albert S. Rogell (1941)

When a black cat suddenly appears after the death of a wealthy, cat-loving recluse, her heirs are mysteriously murdered one by one. The notion that *black* cats, in particular, are linked to evil or bad luck was not a new idea. The Christian Church treated them harshly for centuries, because they believed that the Devil borrowed the coat of a black cat when setting out to torment his victims.

> Anyone who takes himself too seriously always runs the risk of looking ridiculous; anyone who can consistently laugh at himself does not.

Anonymous

STUART LITTLE 2
Dir. Rob Minkoff (2002)

In this second adventure about adopted mouse Stuart, his old enemies—the sneering cat Snowbell and his friend Monty the Mouth—soften enough to help Stuart in his hour of need. For one scene, in which Monty is thrown into a trash can and emerges with a Chinese takeout box on his head, tabby cats Merlin and Magoo, who played Monty, needed weeks of special training. The filmmakers also made an individually tailored takeout box "hat" for the cats, which was trimmed with rubber bands that resembled spilling noodles.

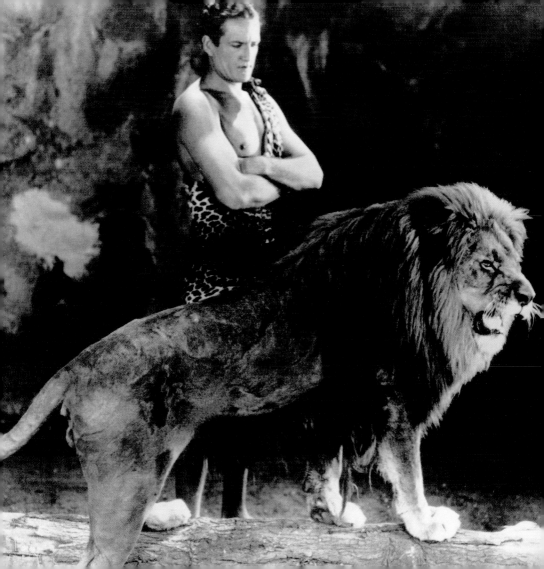

> **The obedience that a combination of sternness and affection had elicited from the cub had become largely habit in the grown lion... Such, then, was the golden lion that roamed the primeval forest with his godlike master.**
>
> Edgar Rice Burroughs

 ## TARZAN AND THE GOLDEN LION
Dir. J. P. McGowan (1927)

Tarzan, played by James Pierce, and his faithful lion companion Jad-bal-ja, journey to the City of Diamonds to save his sister from being sacrificed to a lion god. Acting with big cats was extremely dangerous in the early days of moviemaking. Few precautions were taken, and skirmishes with lions often involved live action between the lions and animal trainers rather than the slow, careful training, animatronics, special effects, and inter-cutting of hundreds of tiny shots that are used nowadays. It is therefore no surprise that in his autobiography, James Pierce wrote of the various hazards he faced when playing Tarzan.

One beautiful April day... all of the aunts' cats followed her to school. After that, even the teachers would not pass her in an empty hallway. Black cats can do that to some people...

Alice Hoffman

 PRACTICAL MAGIC
Dir. Griffin Dunne (1998)

In *Practical Magic*, two young witches, Sally and Gillian Owens, are struggling against a curse that means any man they love will suffer an untimely death. Their black cat is one of the Owens girls' few comforts, and they certainly feel an affinity for their feline companion. In Alice Hoffman's original novel, the witches' black cats play a more significant role and are even named as Cardinal, Crow, Raven, and Magpie. It's a shame that these great feline characters weren't given the screen time they deserved in *Practical Magic*. After all, where would a witch be without her animal familiar?

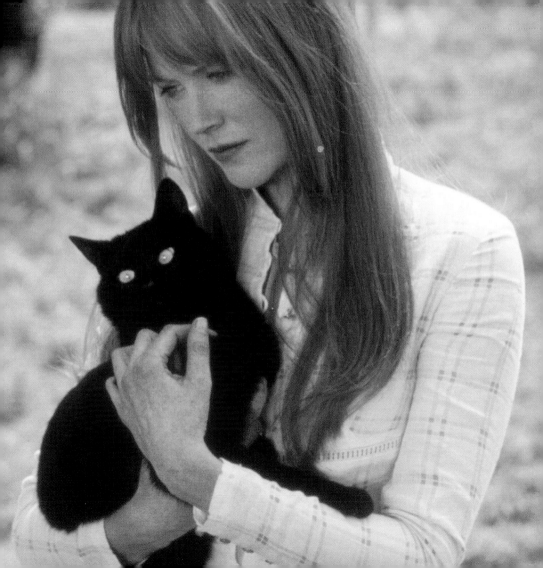

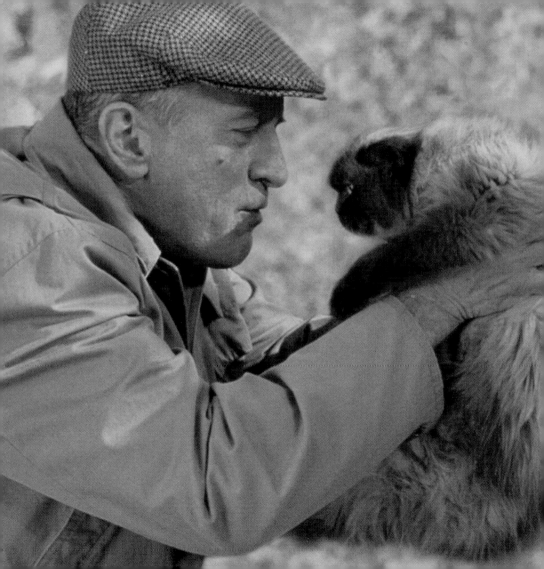

JACK BYRNES: My little baby, we found you! We found you!

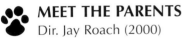

MEET THE PARENTS
Dir. Jay Roach (2000)

In this comedy, cat-hating male nurse Greg Focker meets his girlfriend's ex-CIA father Jack Byrne for the first time. Jack Byrne (played by Robert De Niro) dotes on his arrogant Himalayan cat Mr. Jinx, who lives up to his name and does his bit to make sure the weekend is a disaster. Mr. Jinx was played by two expertly trained five-year old Himalayans named Bailey and Misha, who got along very well with their co-stars and quickly learned all their "lines." Many reviewers agree that the cat scenes are by far the funniest, which is certainly a compliment to the acting skills of Bailey and Misha—considering they were playing alongside Oscar-winning actor Robert De Niro.

I simply can't resist a cat, particularly a purring one.

Mark Twain

 I'M NO ANGEL
Dir. Wesley Rubbles (1933)

Mae West stars as Tira, the fairground lion tamer who controls her big cats as confidently as she manages her men. West's previous film was *She Done Him Wrong*, a sensational hit that saved Paramount Pictures from bankruptcy. In gratitude, Paramount mogul Adolph Zukor promised the actress a free hand with her next movie. So, she chose to fulfill a dream she'd had since her childhood trips to see the Boston Lions act—casting herself as a lion tamer and doing all her own stunts.

CATWOMAN: I am Catwoman! Hear me roar!

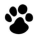 **BATMAN RETURNS**
Dir. Tim Burton (1992)

The animal trainers on the set of *Batman Returns* really had their work cut out for them, having to work with 20 cats, a monkey, a poodle, a bird, and a whole army of penguins. The lead cat Miss Kitty is shy secretary Selina's only companion, but when Selina is transformed into the seductive Catwoman, many other cats are drawn to her. The cats sitting on the ledge outside her apartment building really *were* sitting on a window ledge, but there was no need to worry about their safety. They were all wearing specially-designed harnesses that were attached to hooks on the ledge to prevent them from slipping off.

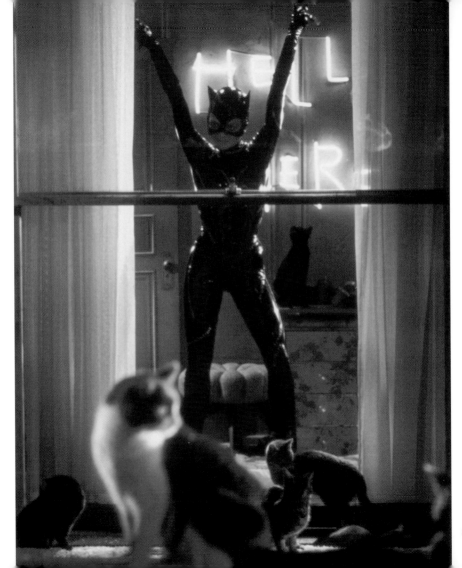

A friend is one before whom I may think aloud.

Ralph Waldo Emerson

 THE ADVENTURES OF MILO AND OTIS
Dir. Masanori Hata (1986)

After a lifetime of work as a zoologist, a documentary filmmaker, and founder of an animal sanctuary, Masanori Hata decided to make a feature film about the adventures of an orange kitten named Milo and her friend, Otis the Pug. His direction of Milo was so realistic that a dispute still rages between those who know him to be devoted to animals and others who believe that the kitten must have been ill-treated in the making of the film in order to give such a great performance.

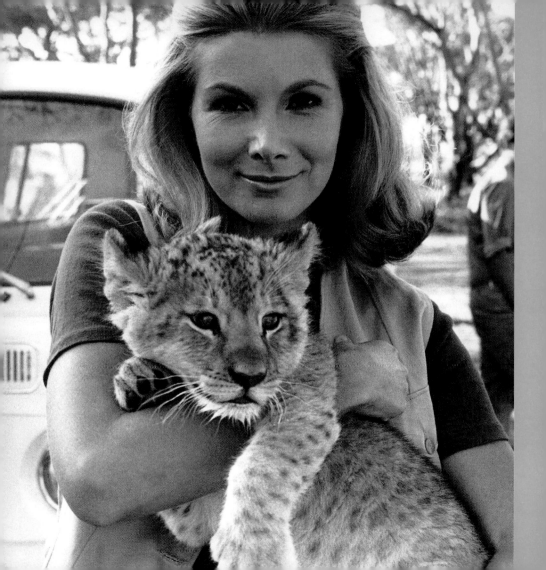

A thing of beauty, strength, and grace lies behind that whiskered face.

Anonymous

 LIVING FREE
Dir. Jack C. Couffer (1972)

In *Born Free*, Elsa the lioness was successfully returned to the wild, where she found a mate and gave birth to three cubs. In the sequel *Living Free*, George and Joy Adamson once again find themselves trying to ensure the survival of three half-wild lion cubs after Elsa dies. Elsa's spirit, however, lives on. The remarkable lion was the inspiration for both the Born Free Foundation and the Elsa Wild Animal Appeal, organizations that have pioneered the protection and conservation of animals in their natural habitats all over the world.

Photo Credits

All images are courtesy of the Kobal Collection.

Text Credits

p.9: Dialogue from *Stuart Little* (Columbia Pictures/Franklin/Waterman Productions/Global Medien KG; screenwriters M. Night Shyamalan and Greg Brooker). p.13: Dialogue from *Rudyard Kipling's The Jungle Book* (Walt Disney Pictures; screenwriters Stephen Sommers, Ronald Yanover, and Mark D. Geldman). p.18: Dialogue from *Anger Management* (Happy Madison/Jack Giarraputo Productions/Revolution Studios; screenwriter David Dorfman). p.21: Extract © William Lyon Phelps. p.22: Tagline from *That Darn Cat* (Walt Disney Pictures; screenwriters S.M. Alexander and L.A. Karaszewski). p.26: Tagline from *Clarence the Cross-Eyed Lion* (Ivan Tors Films Inc./MGM; screenwriters Art Arthur, Alan Caillou, and Marshall Thompson). p.29: Dialogue from *Breakfast at Tiffany's* (Jurow Shepherd/Paramount; screenwriter George Axelrod). p.30: Dialogue from *Cats & Dogs* (Mad Chance/Warner Bros./Zide-Perry Productions; screenwriters John Requa and Glenn Ficarra). p.39: Dialogue from *Rhubarb* (Paramount; screenwriters Francis M. Cockrell, Dorothy Davenport, and David Stern). p.43: Dialogue from *Doctor Dolittle* (20th Century Fox/Davis Entertainment/Joseph M. Singer Entertainment; screenwriters Nat Mauldin and Larry Levin). p.56: Tagline from *The Cat From Outer Space* (Walt Disney Pictures; screenwriter Ted Key). p.70: Dialogue from *Thomasina* (Walt Disney Pictures; screenwriter Robert Westerby). p.81: Extract from *Tarzan and the Golden Lion* by Edgar Rice Burroughs (Ballantine Books, 1981). p.82: Extract from *Practical Magic* by Alice Hoffman (Vintage, 2002). p.85: Dialogue from *Meet the Parents* (DreamWorks SKG/Nancy Tenenbaum Productions/Tribeca Productions/Universal Pictures; screenwriters Jim Herzfeld and John Hamburg). p.88: Dialogue from *Batman Returns* (Polygram Pictures/Warner Bros.; screenwriter Daniel Waters).

We would like to give thanks to the many talented screenwriters whose words have enriched this book. Every effort has been made to acknowledge current copyright holders and to contact them where necessary. Any omission is unintentional and the publisher would be pleased to hear from any copyright holders not acknowledged above.

First edition for North America published in 2004 by
Barron's Educational Series, Inc.

First published by MQ Publications Limited
12 The Ivories, 6-8 Northampton Street, London, England
website: www.mqpublications.com

Editor: Tracy Hopkins

All inquiries should be addressed to:
Barron's Educational Series, Inc.
250 Wireless Boulevard
Hauppauge, New York 11788
www.barronseduc.com

International Standard Book No. 0-7641-5719-1

Library of Congress Catalog Card No. 2003107539

Printed and bound in France

9 8 7 6 5 4 3 2 1